Coloring on the Go

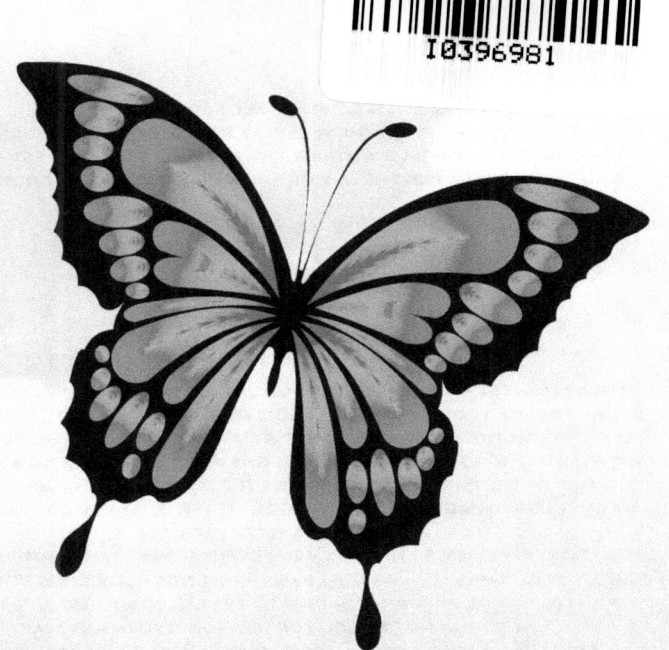

by
Tabz Jones

COPYRIGHT ©TABZ JONES ALL RIGHTS RESERVED.
THIS BOOK OR ANY PORTION THEREOF MAY NOT BE REPRODUCED OR USED IN ANY MANNER WHATSOEVER WITHOUT THE EXPRESS WRITTEN PERMISSION OF THE AUTHOR EXCEPT FOR THE USE OF BRIEF QUOTATIONS IN A BOOK REVIEW.

FIRST EDITION 2017

TABZ JONES
PO BOX 2137
ALMA, AR. 72921
WWW.GOTHICTOGGS.NET

I HERBY GRANT PERMISSION TO THE PURCHASER OF THIS BOOK THE RIGHT TO SHARE FINISHED COLORED PAGES FROM THIS BOOK ON SOCIAL MEDIA SITES WITH THE STIPULATION THAT A LINK BACK TO MY WEBSITE (WWW.GOTHICTOGGS.NET) OR A COPYRIGHT MARK (© TABZ JONES) MUST BE POSTED WITH THE PAGE. I DO NOT GRANT THE PURCHASER THE RIGHT TO POST ANY UNCOLORED PAGES FROM THIS BOOK EITHER IN WHOLE OR PART ON ANY SOCIAL MEDIA SITES WITH THE
EXCEPTION OF REVIEWS AND ONLY WITH EXPRESS WRITTEN PERMISSION ON A CASE BY CASE BASIS. COLORING A PAGE FROM THIS BOOK DOES NOT CONFER ANY INTELLECTUAL PROPERTY RIGHTS TO THE COLORIST. FINISHED COLORED PAGES MAY NOT BE SOLD OR DISTRUBUTED IN ANY WAY.
I RETAIN ALL INTELLECTUAL PROPERTY RIGHTS TO MY ARTWORKS.

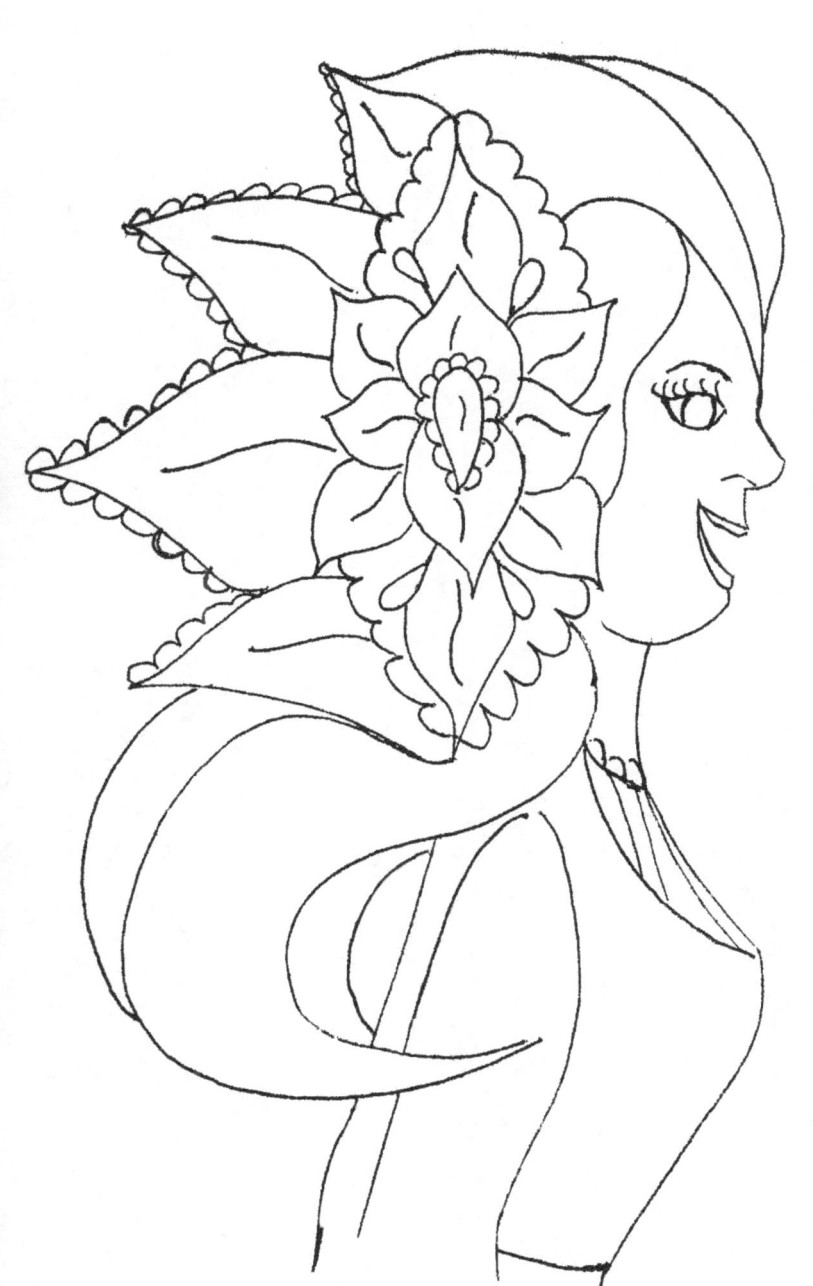

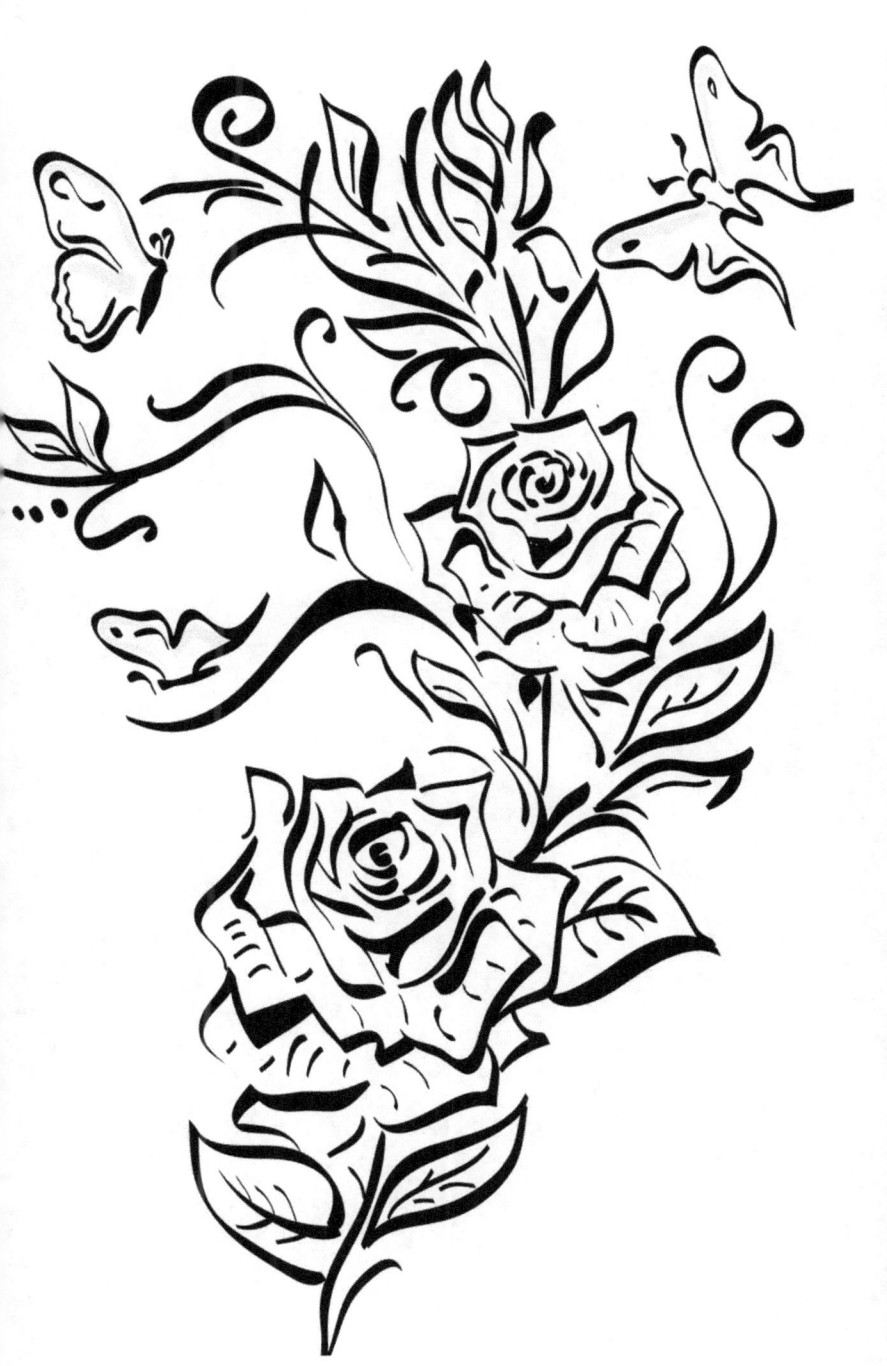

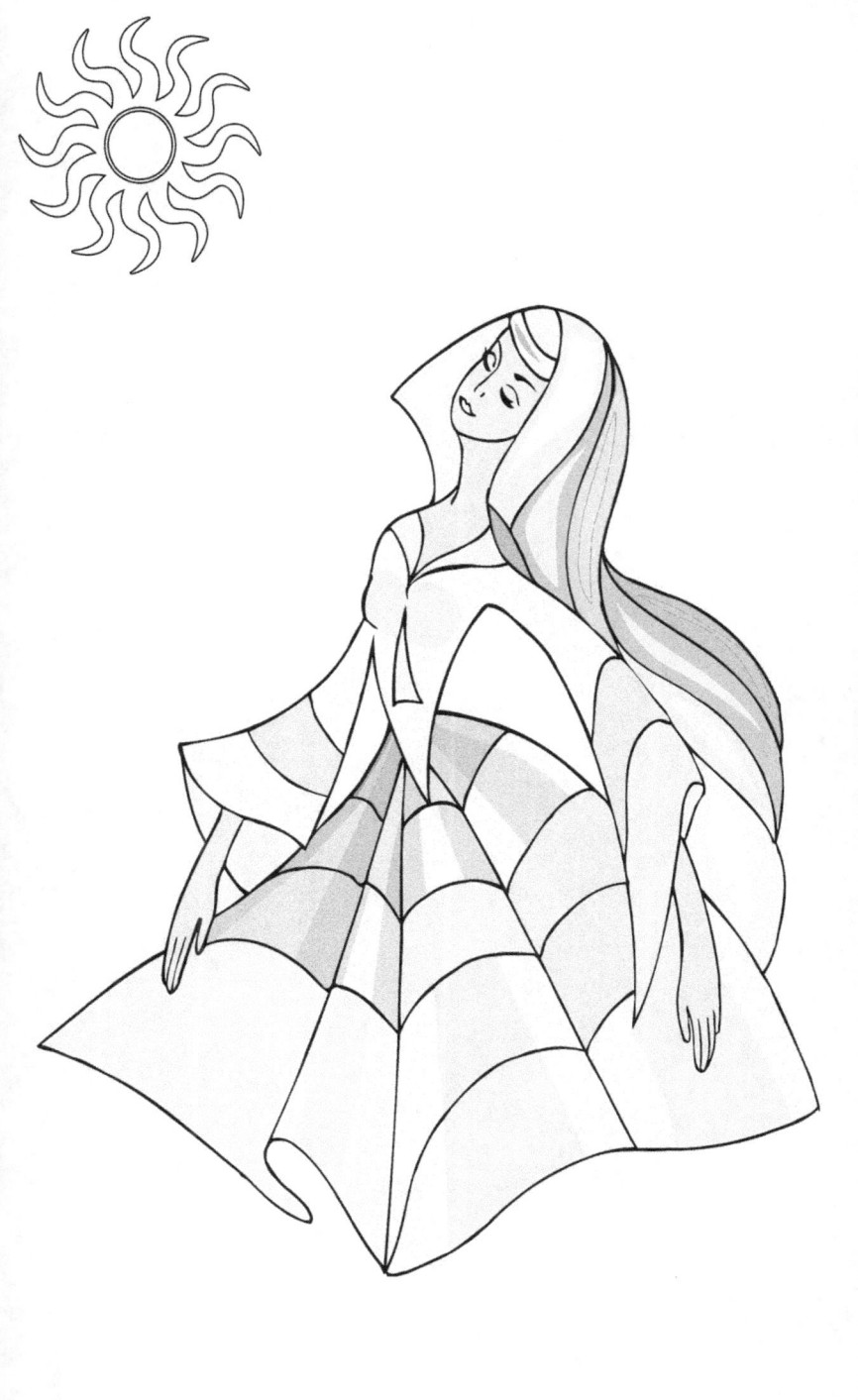

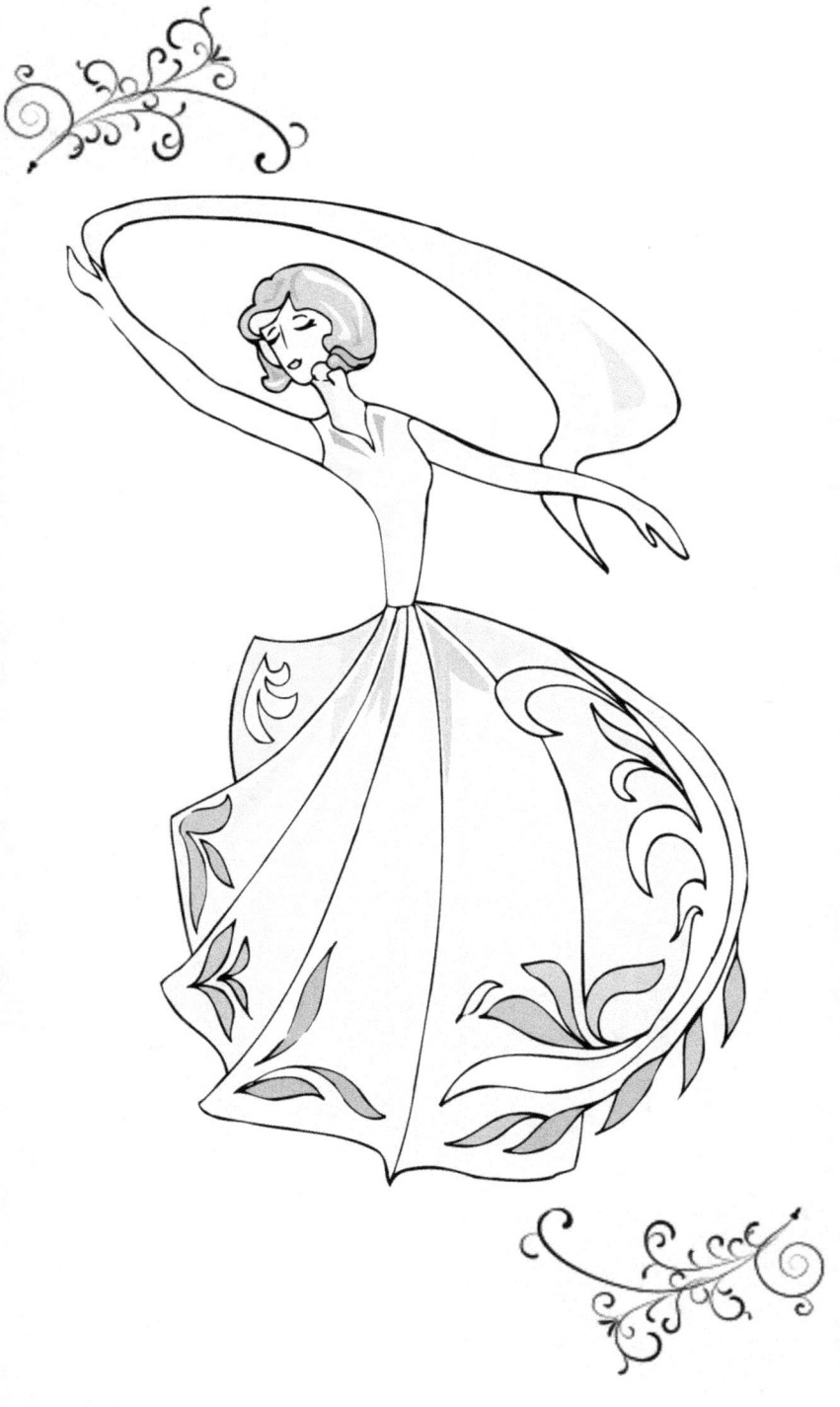

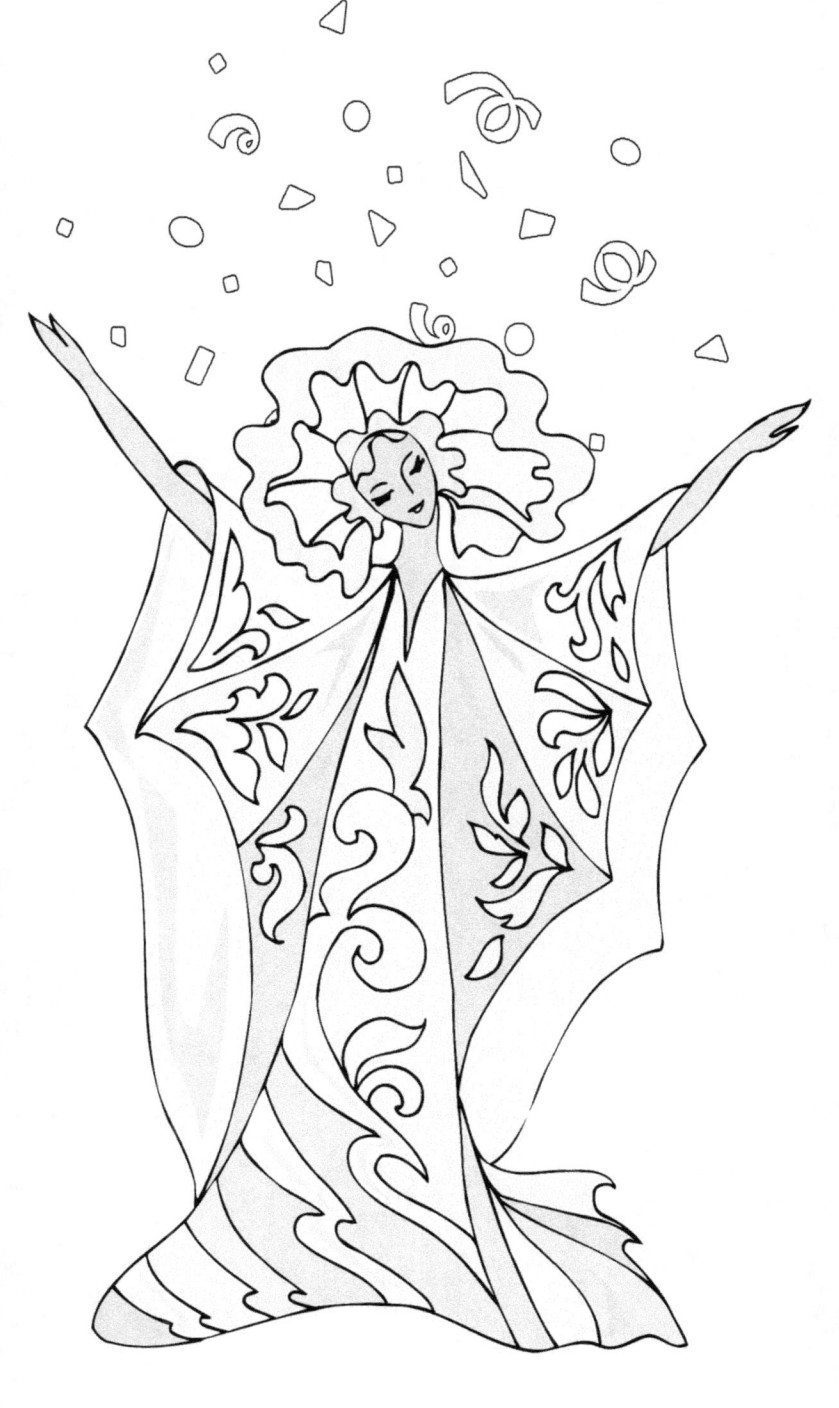

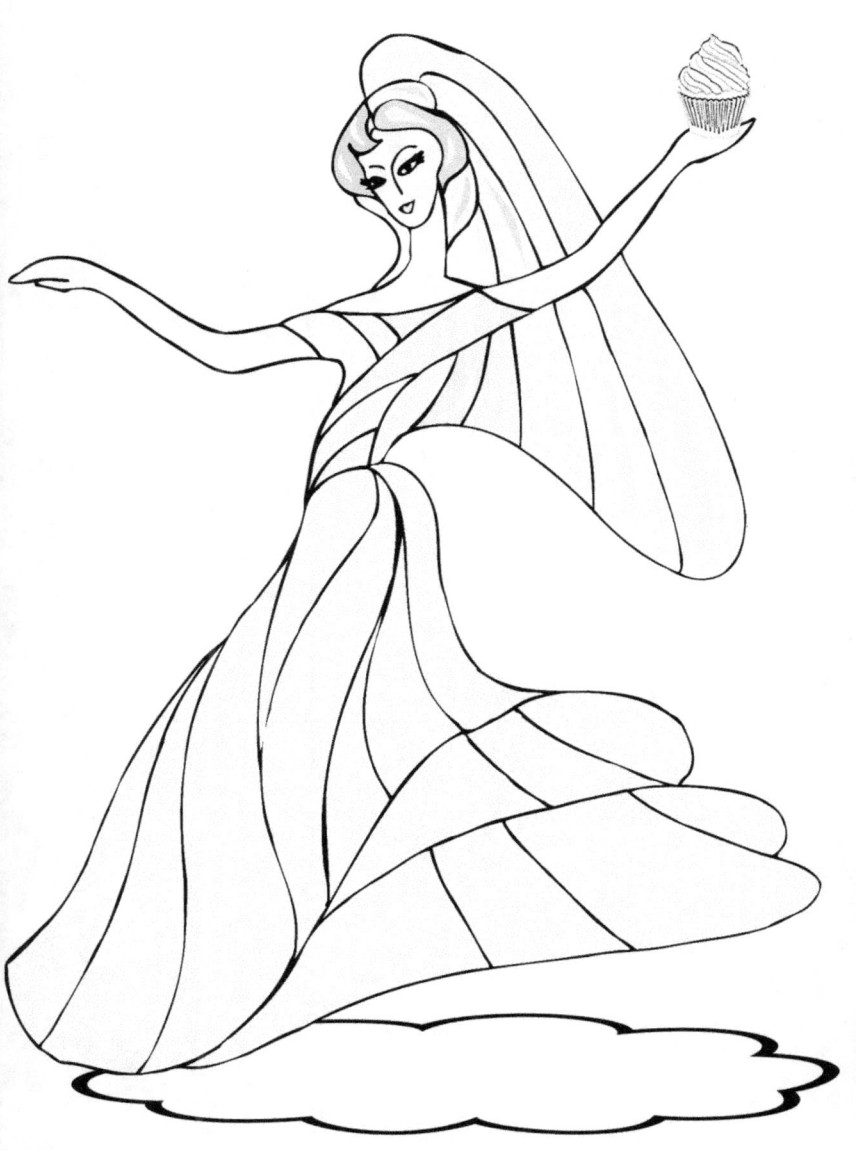

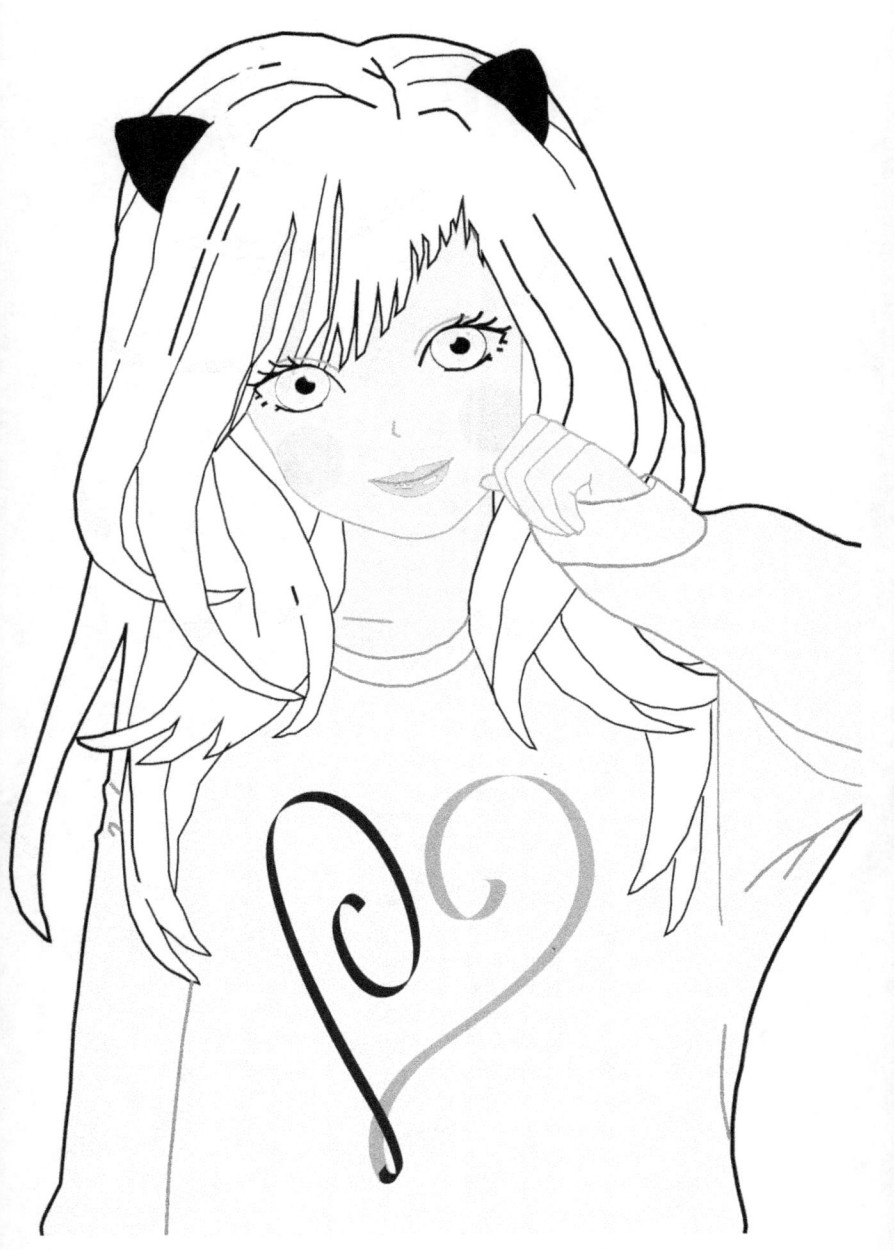

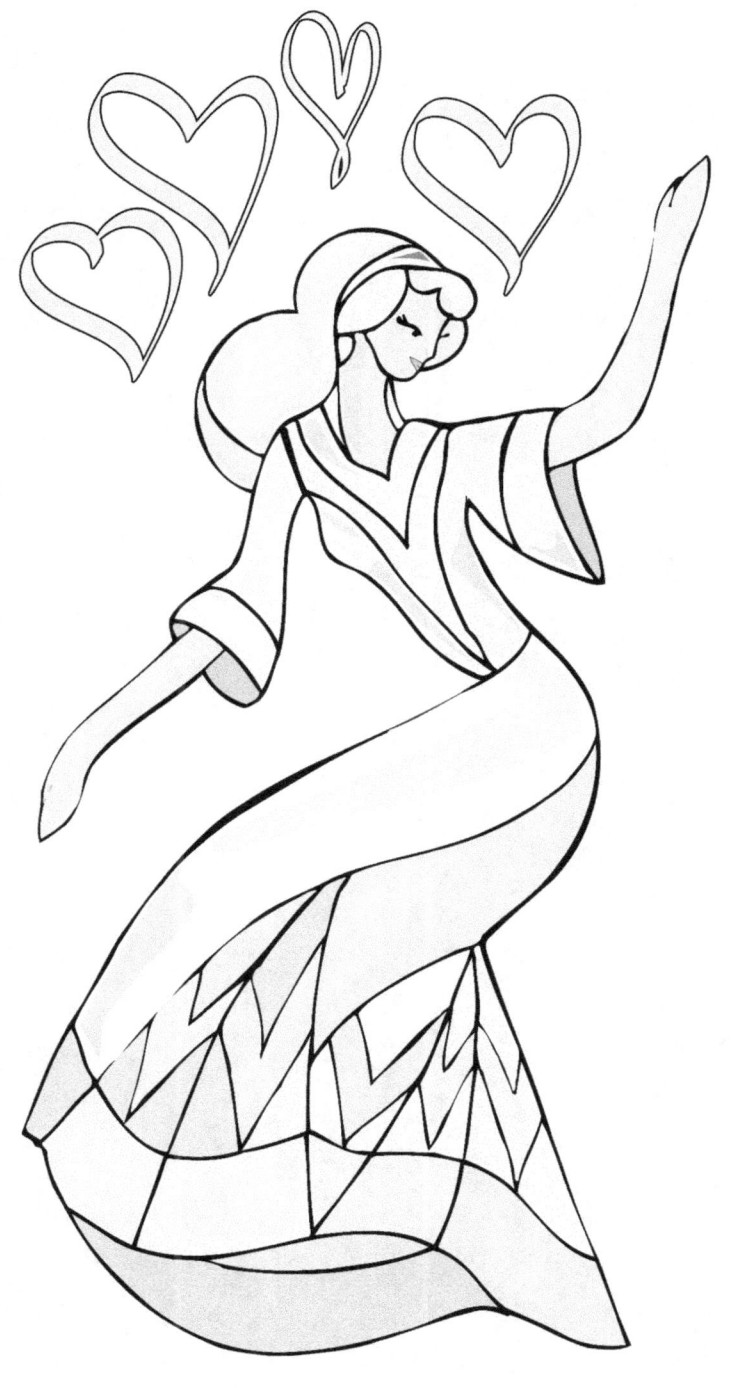

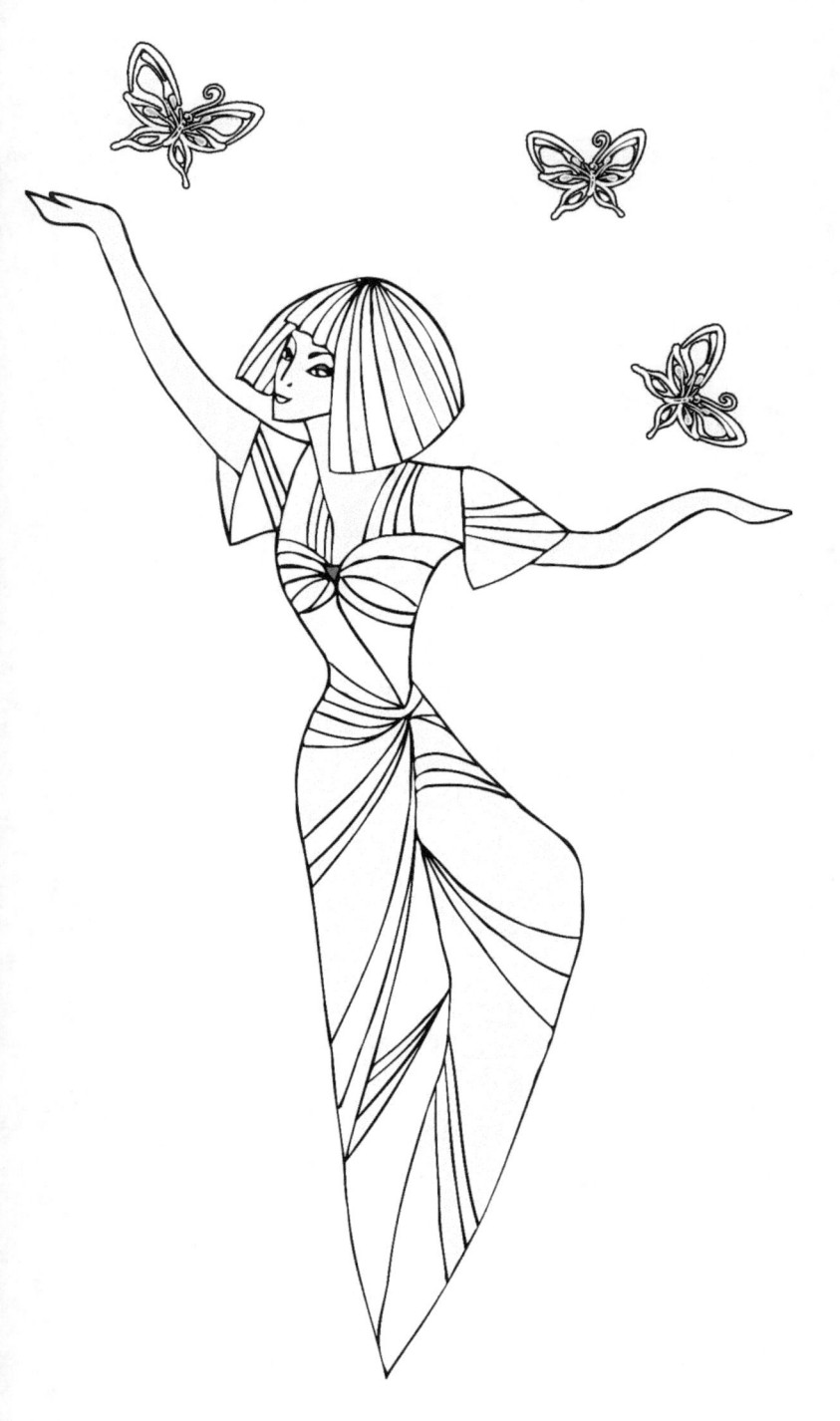

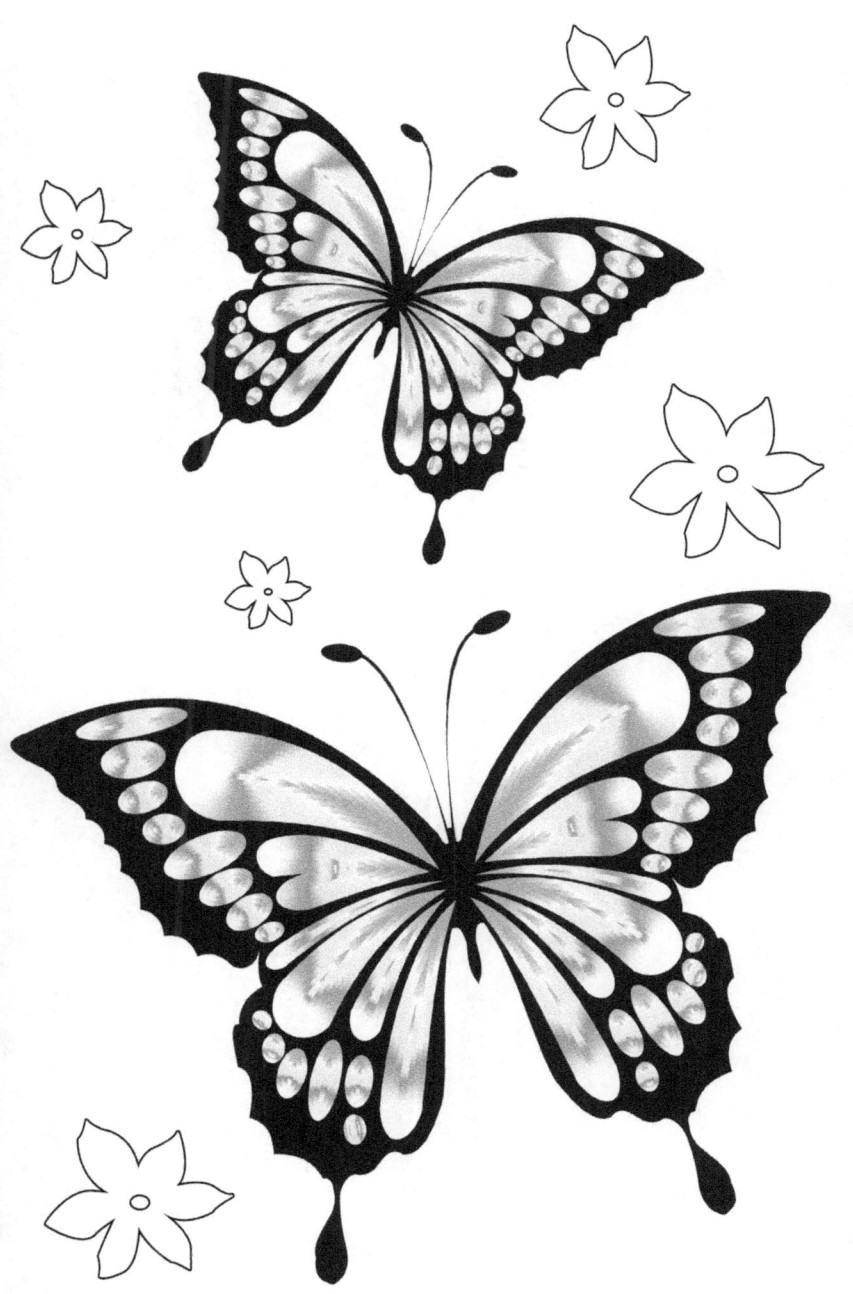

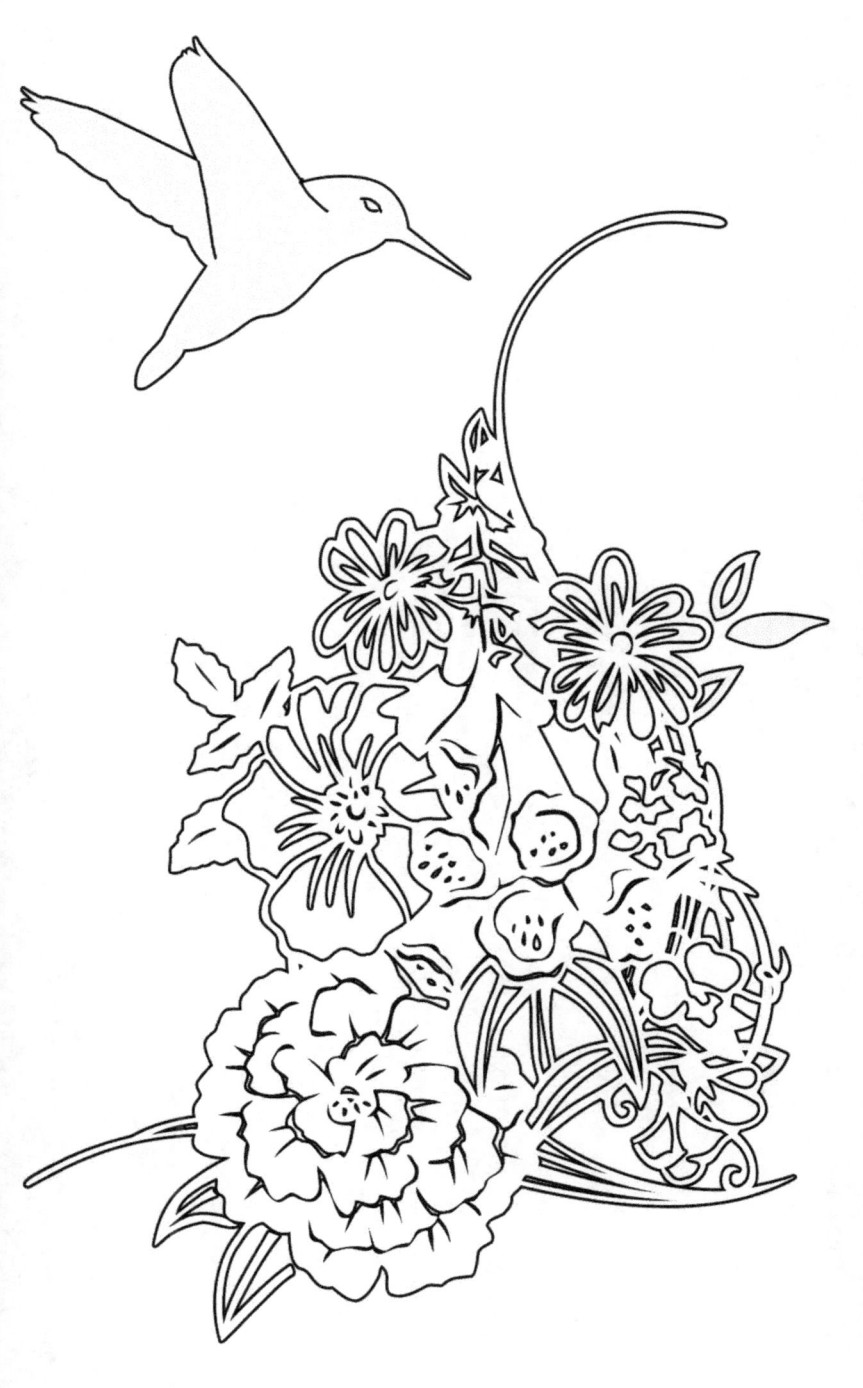

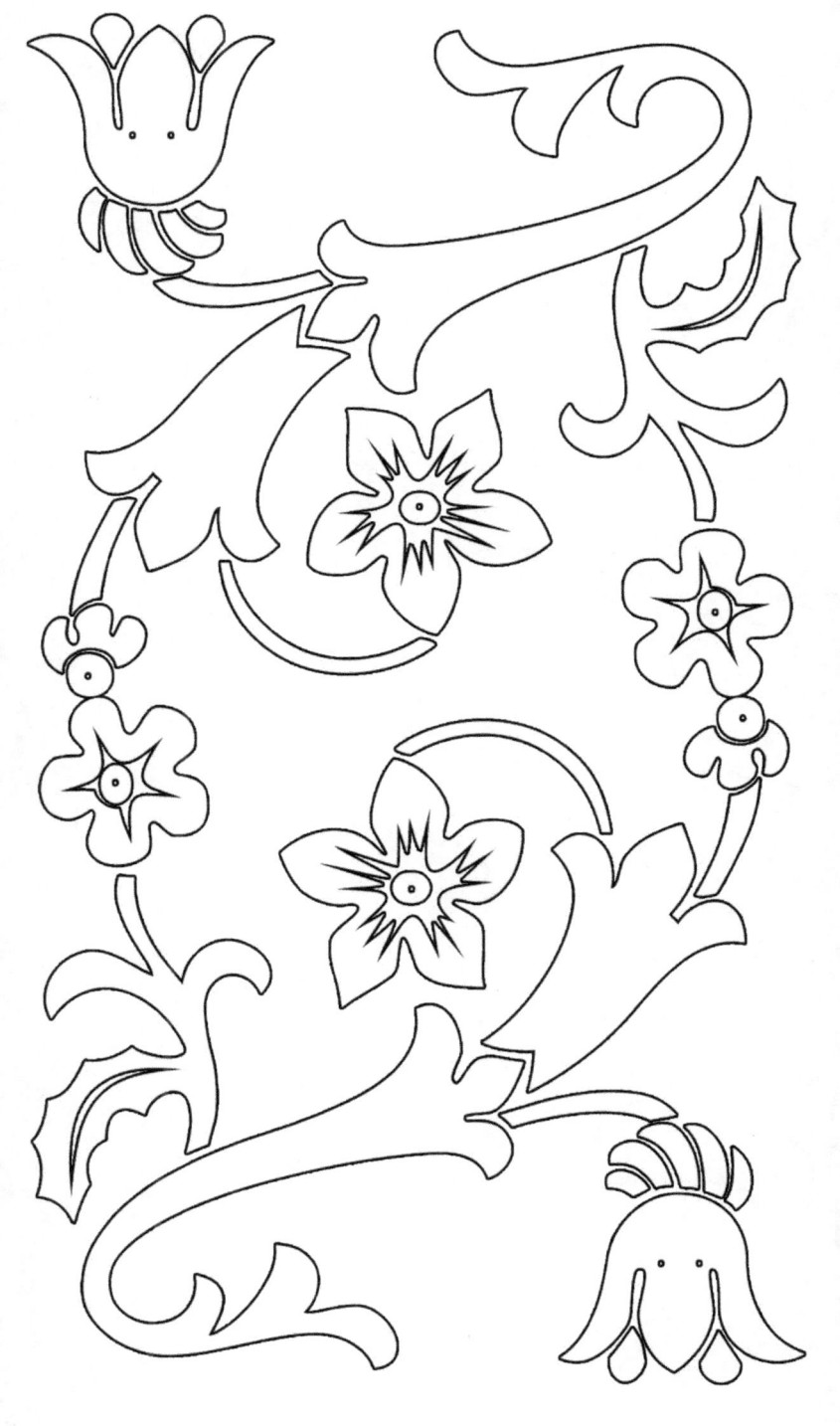

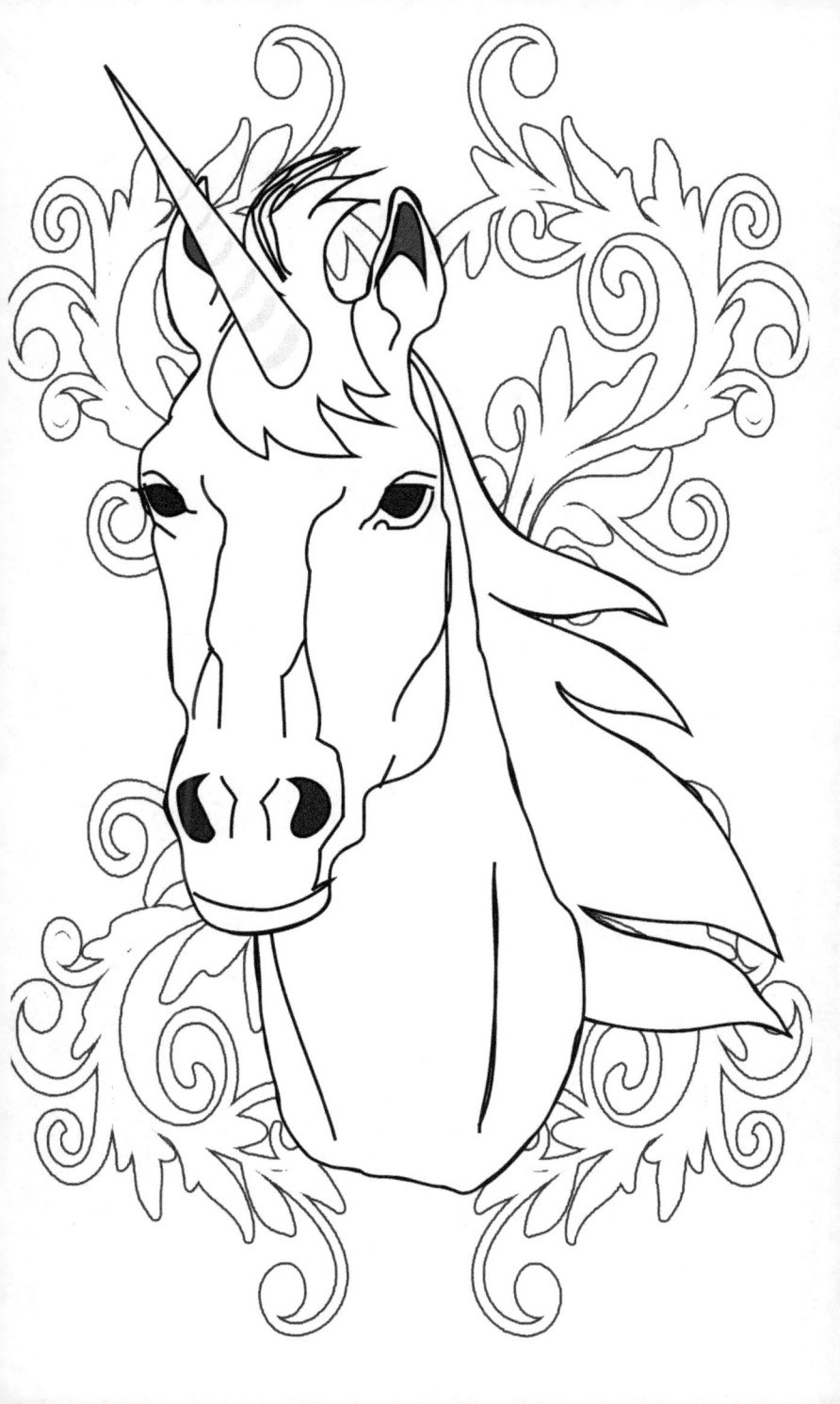

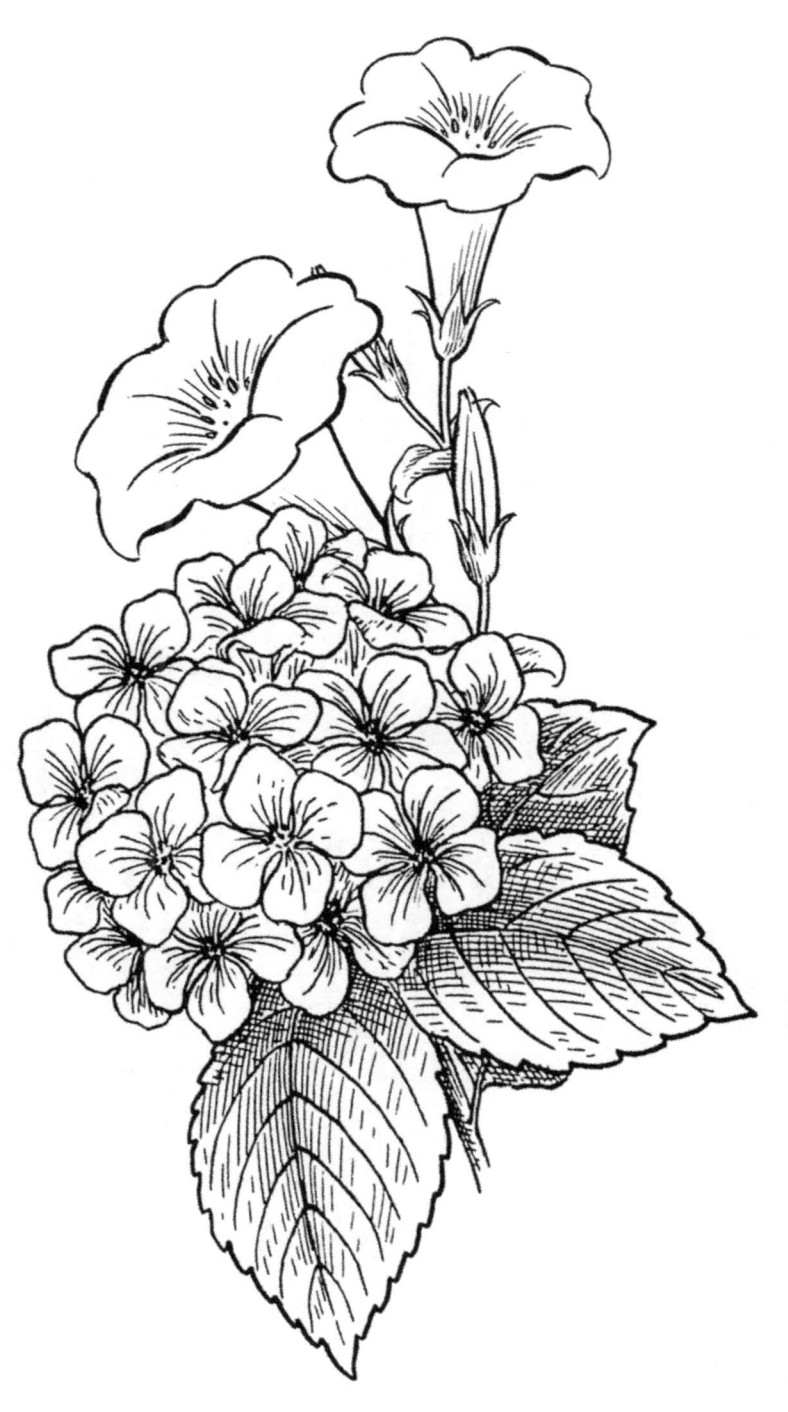

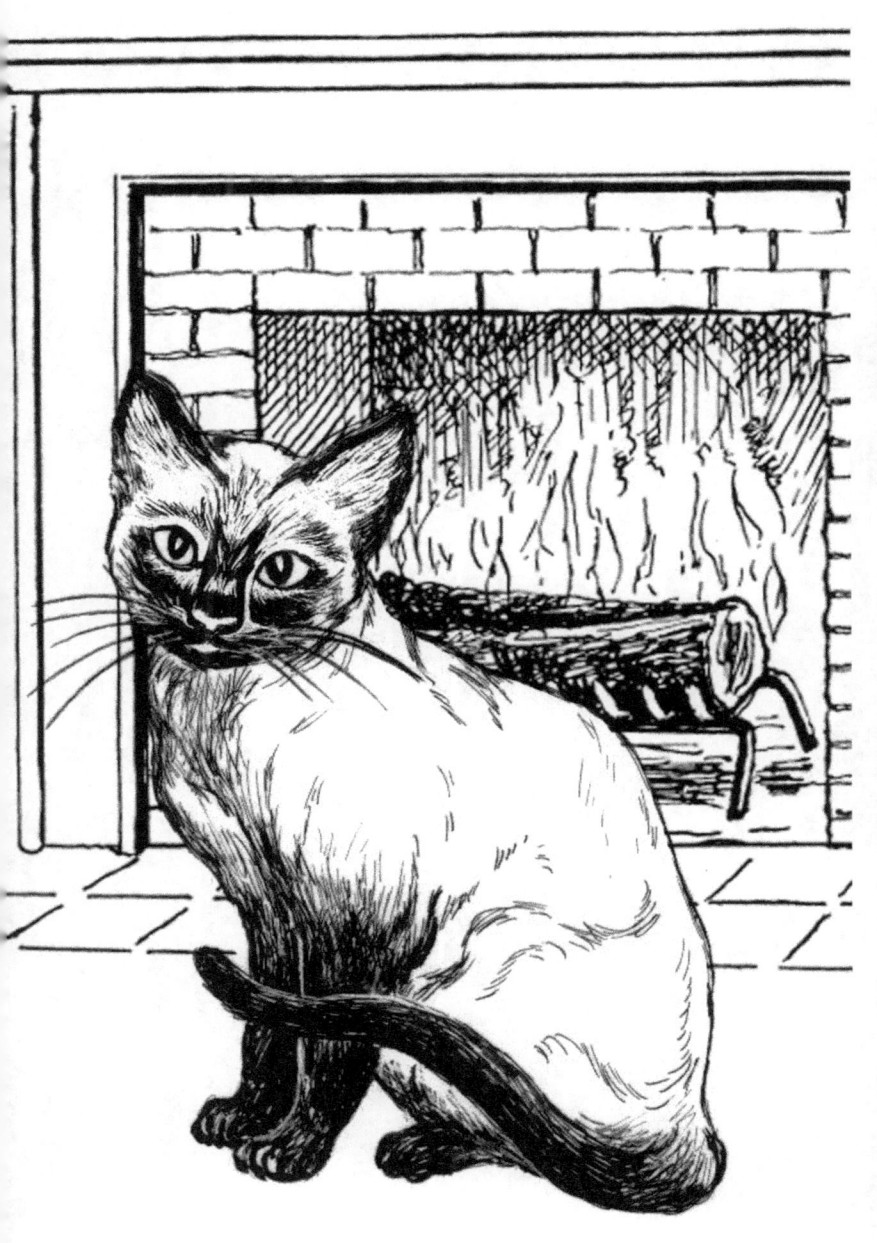

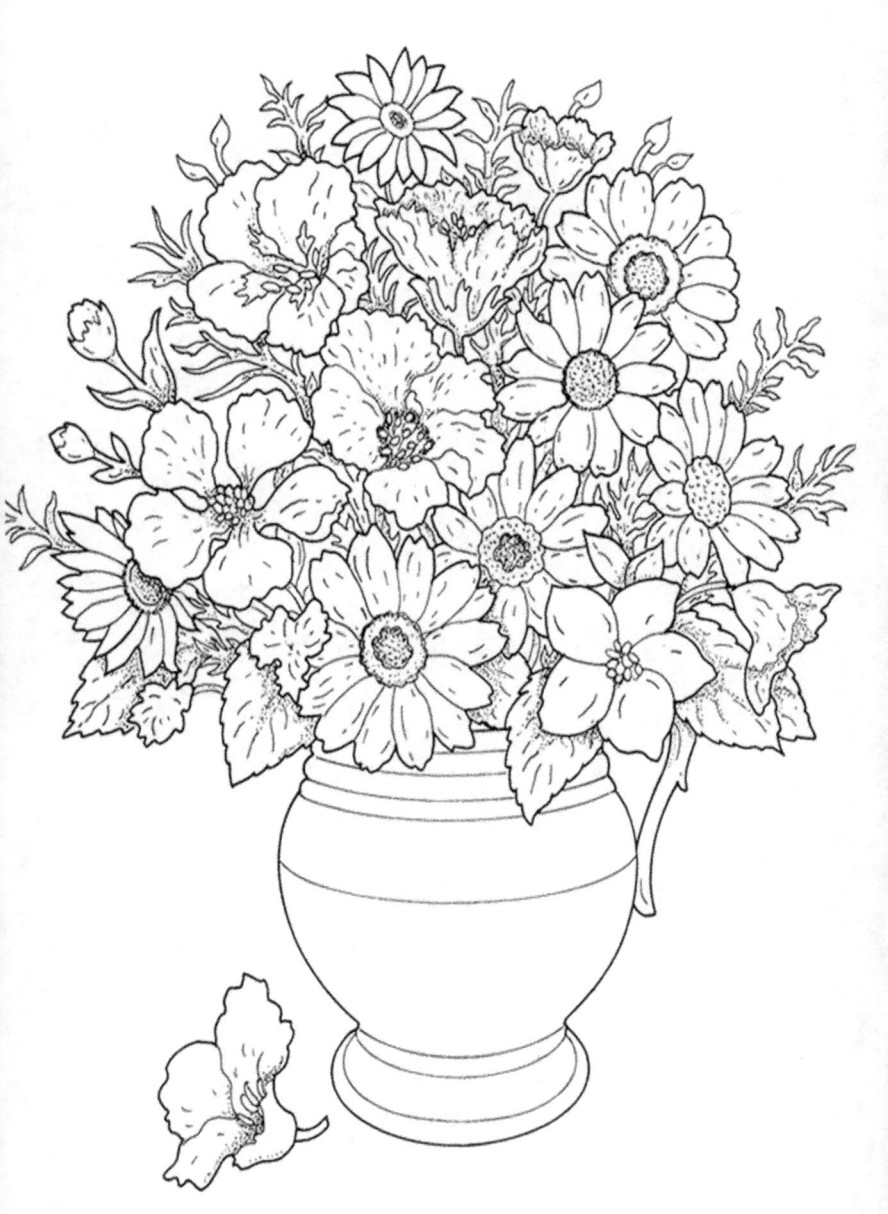

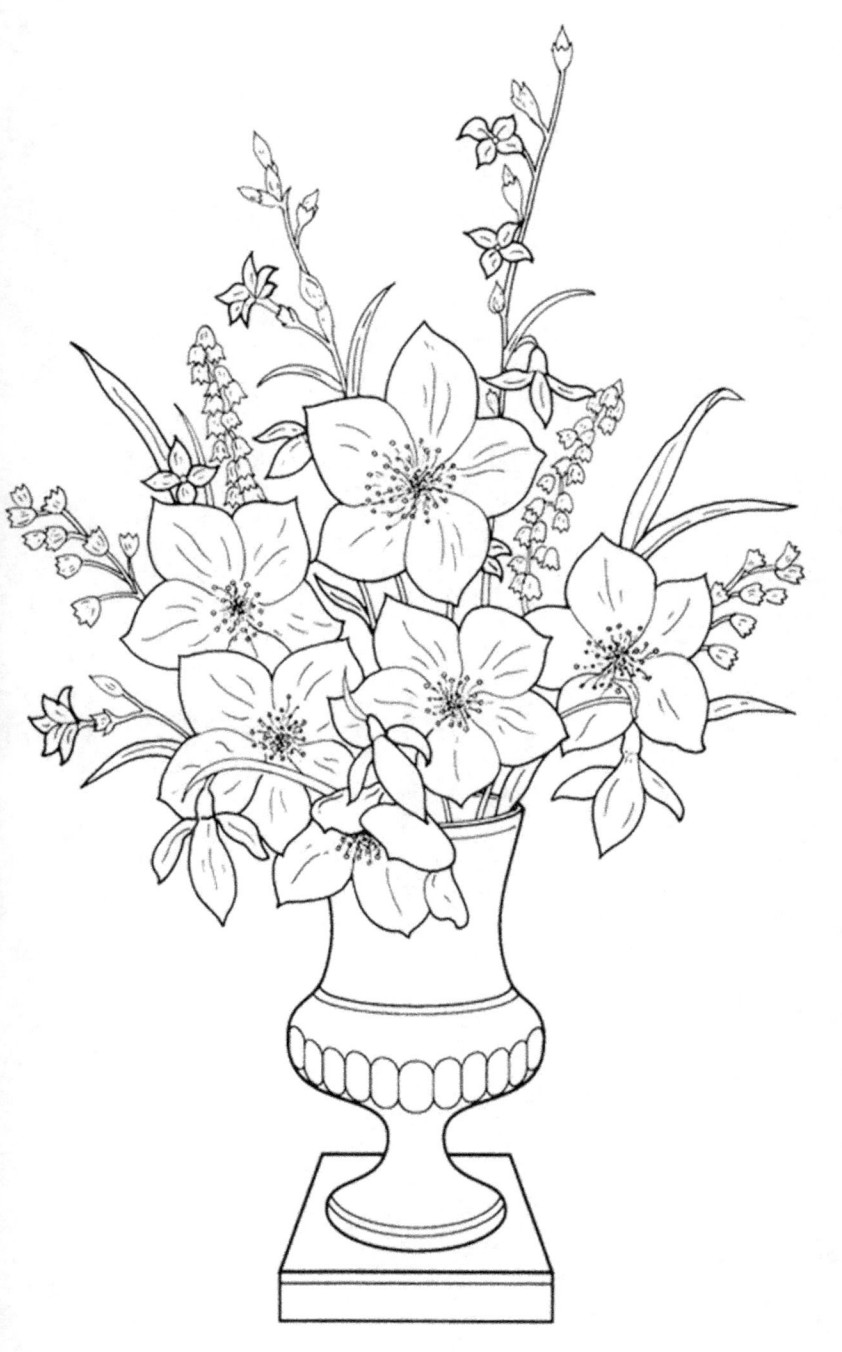

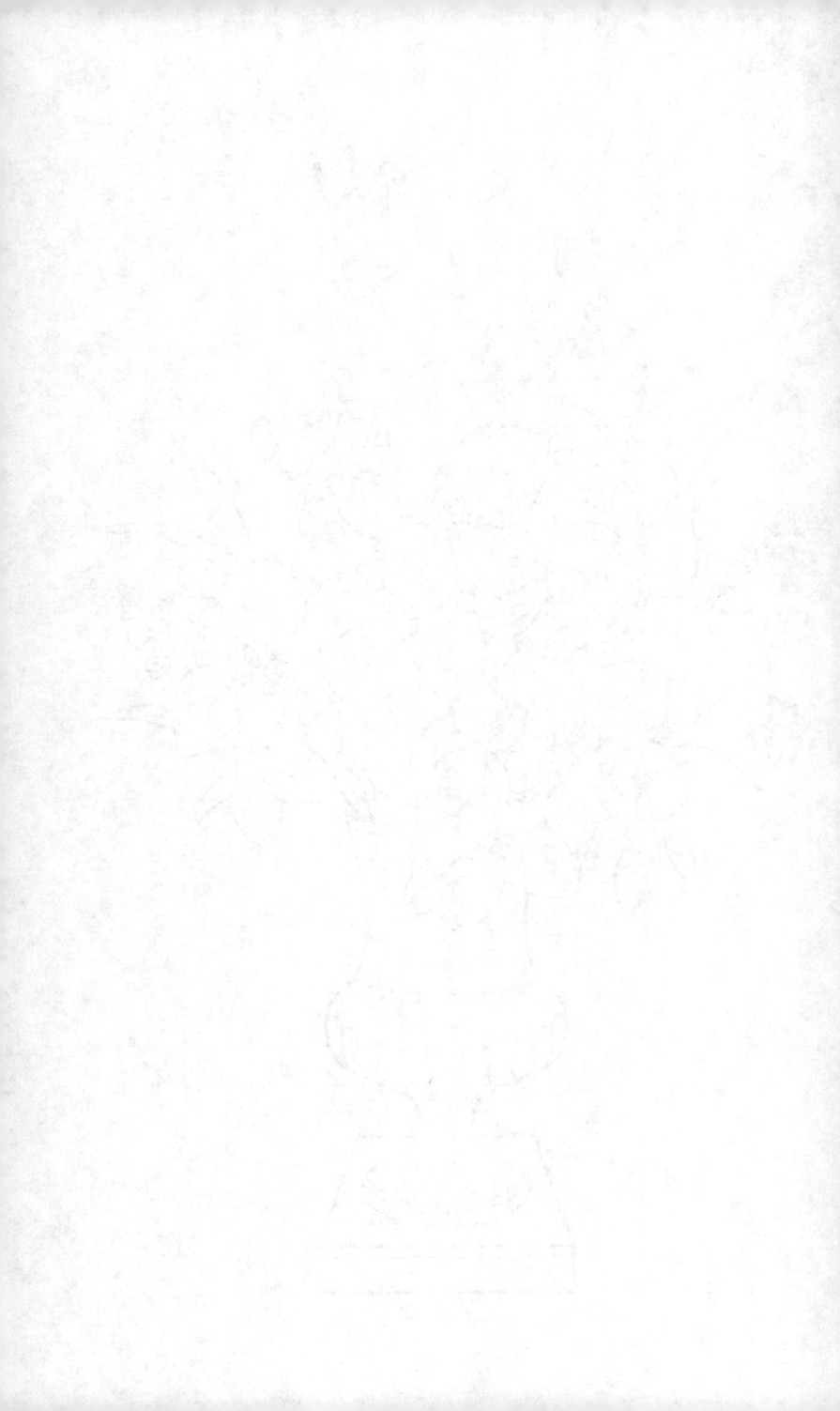

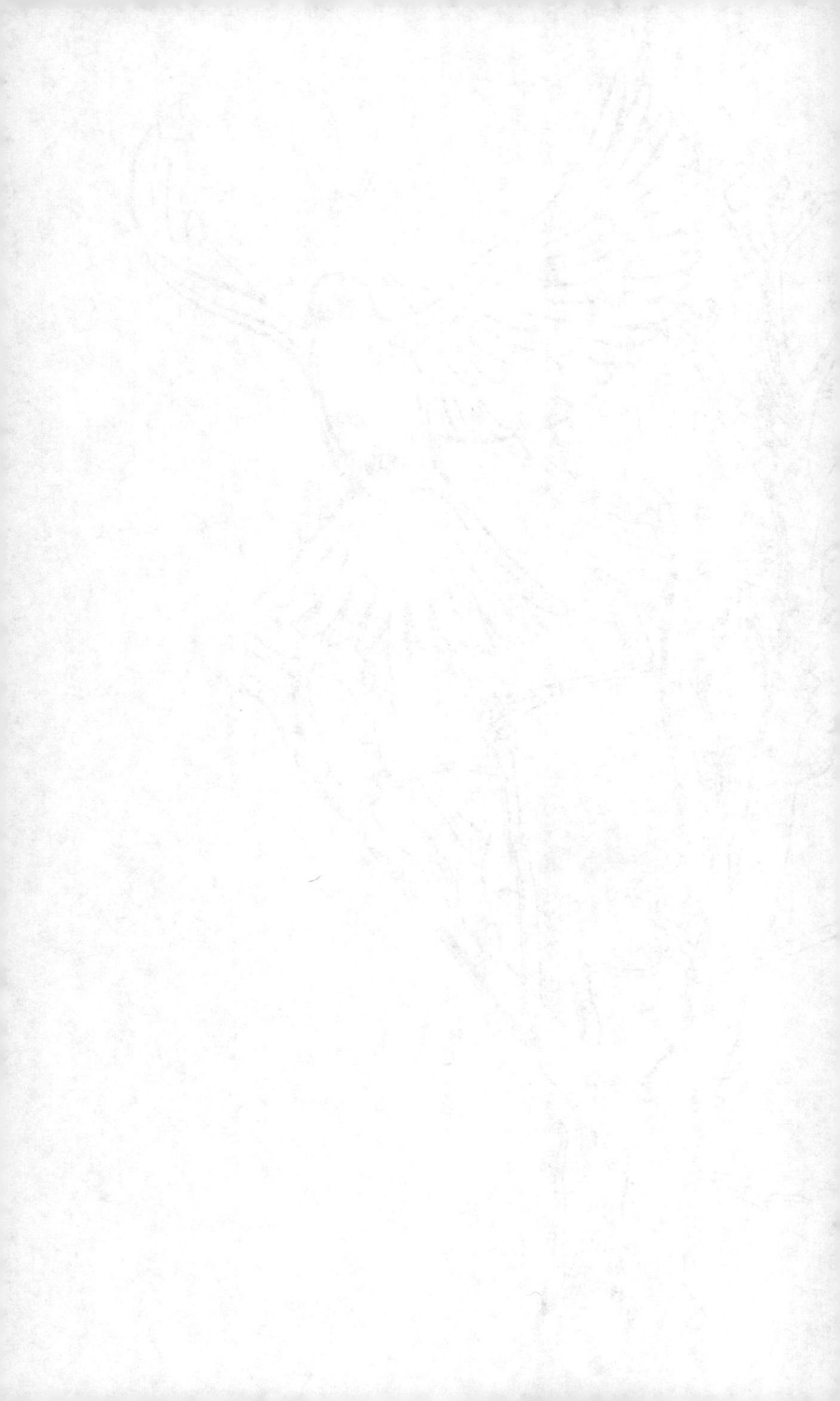

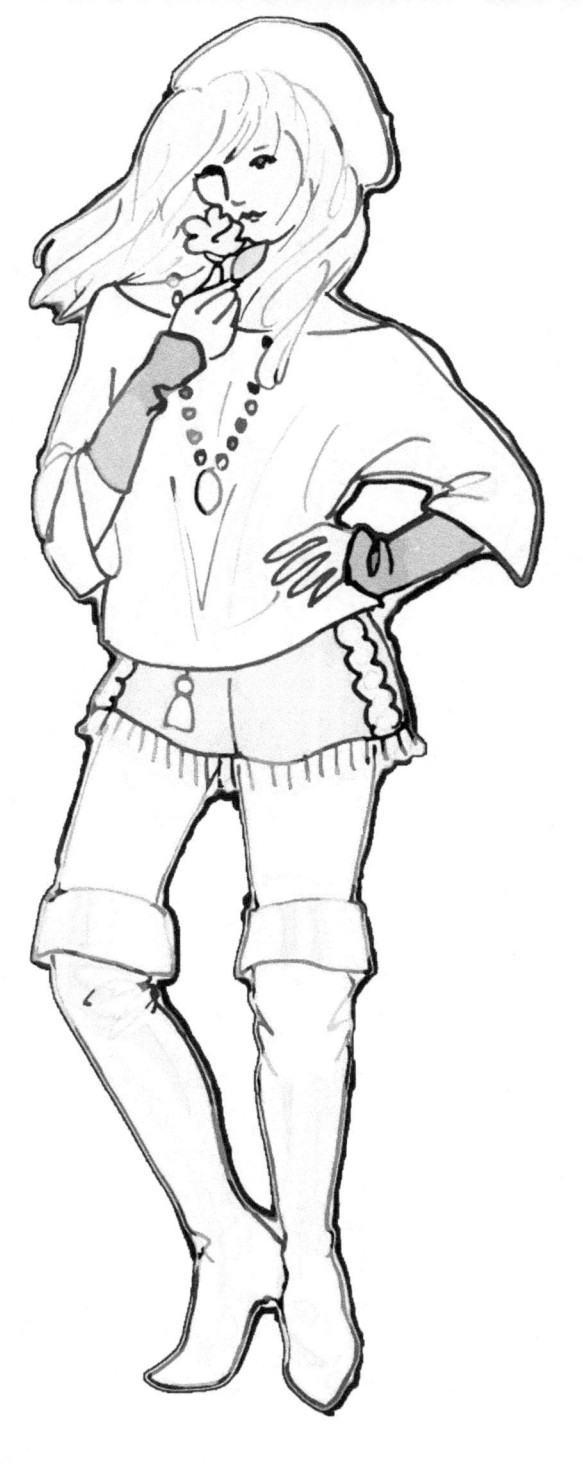

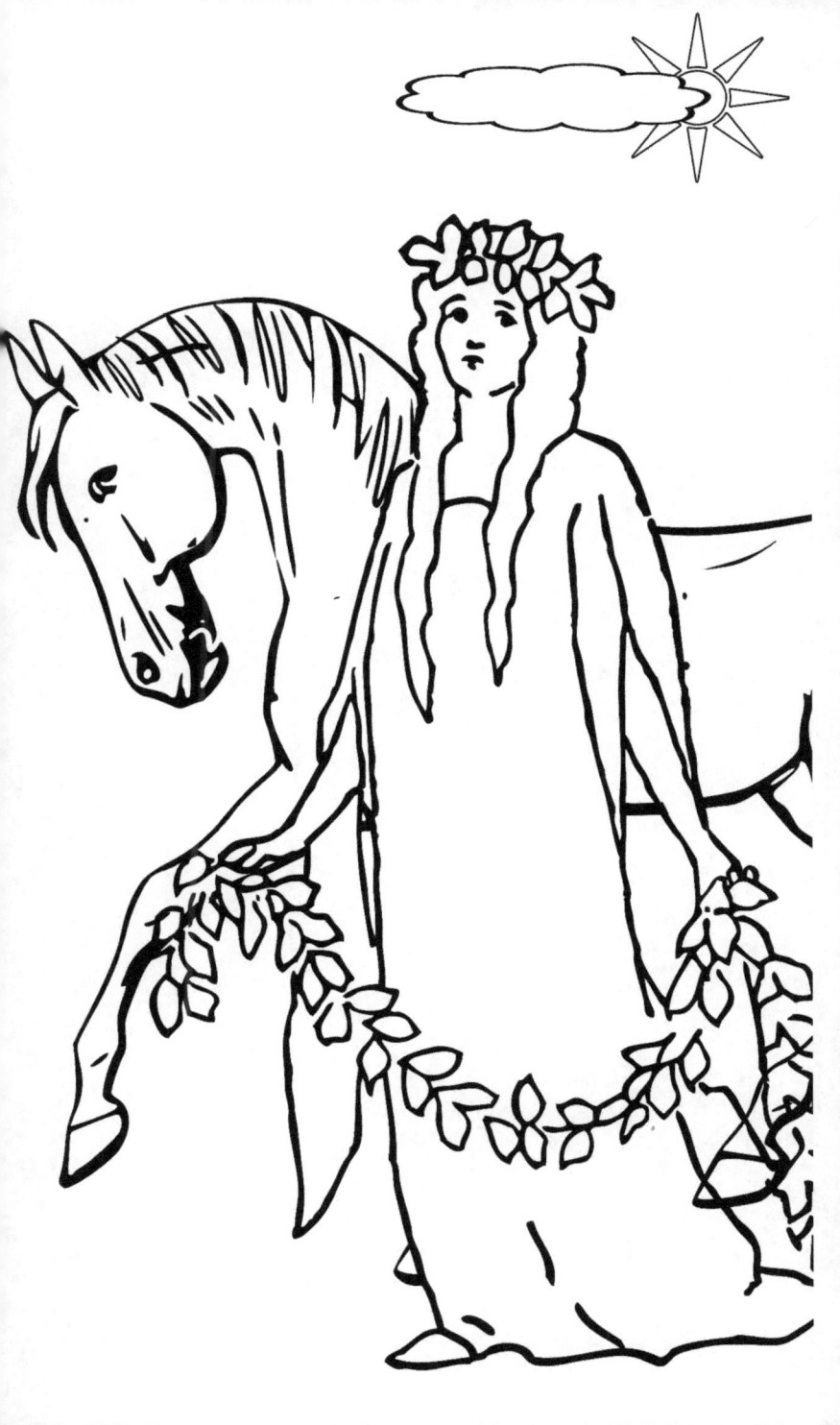

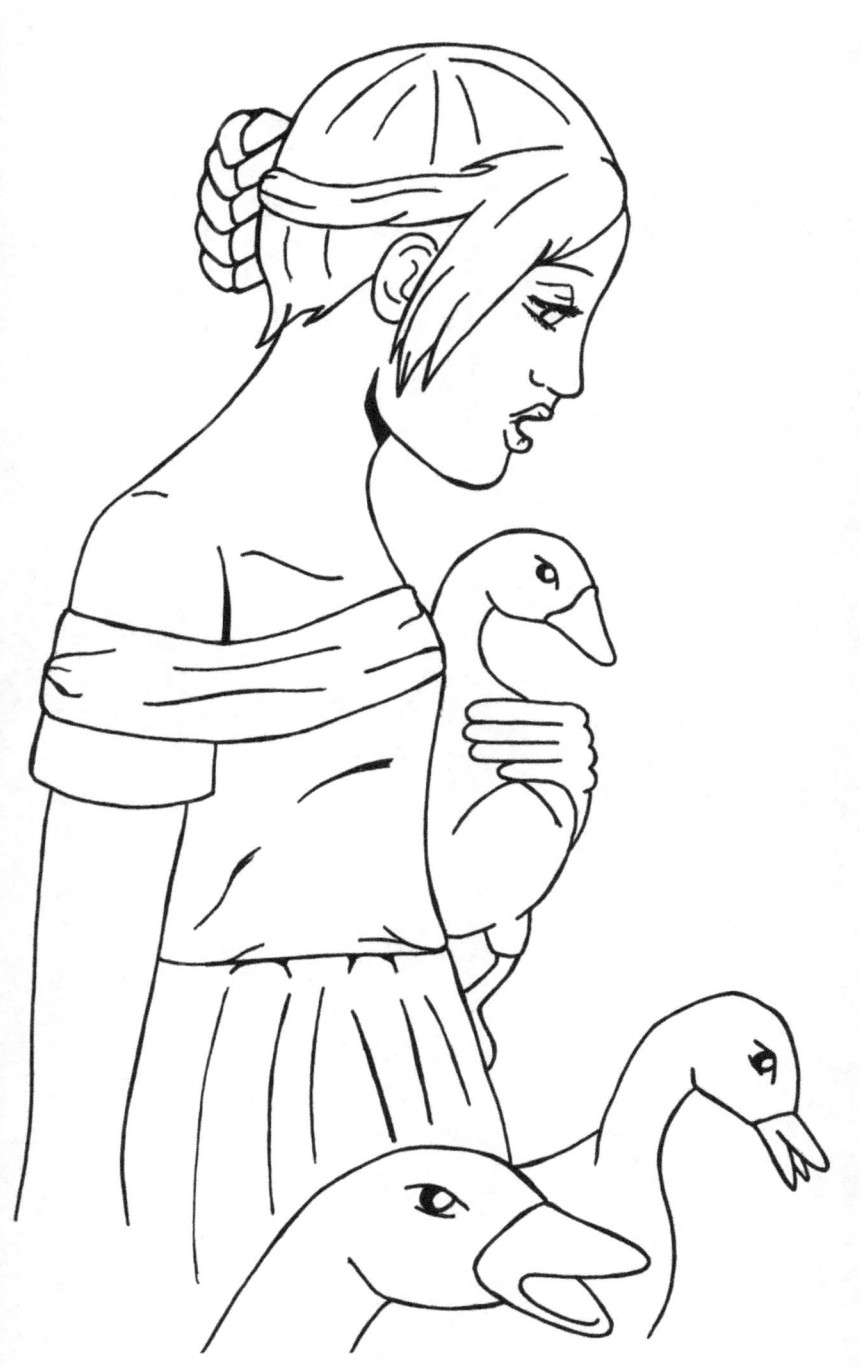

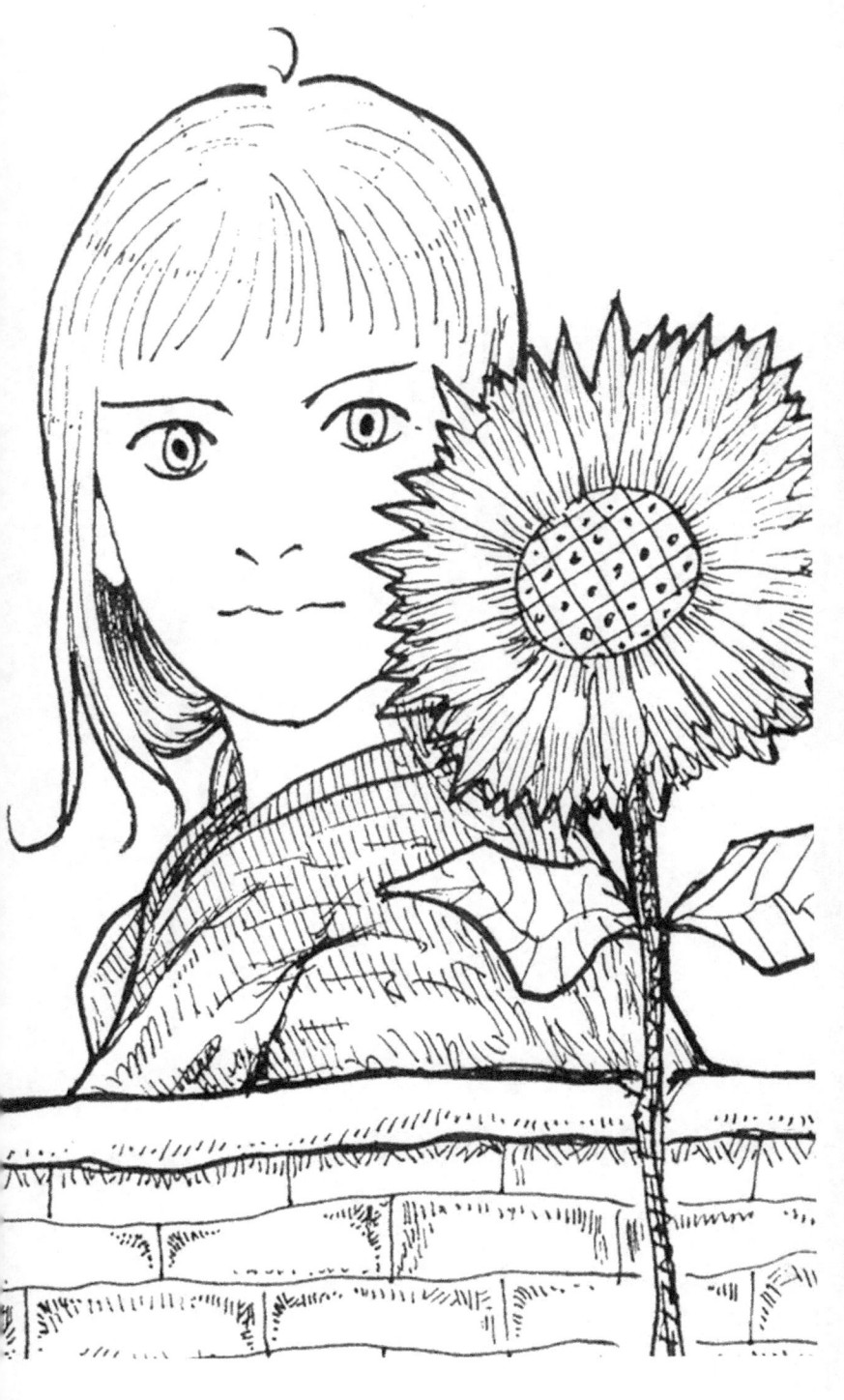

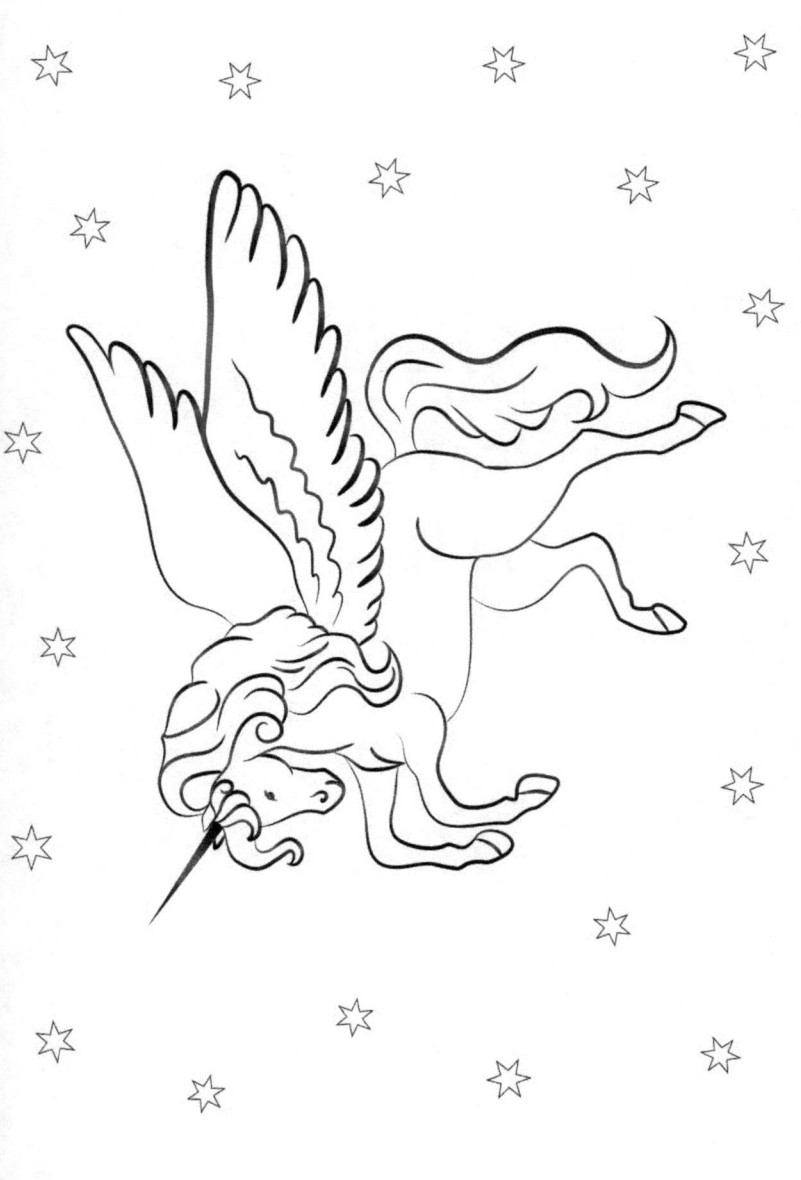

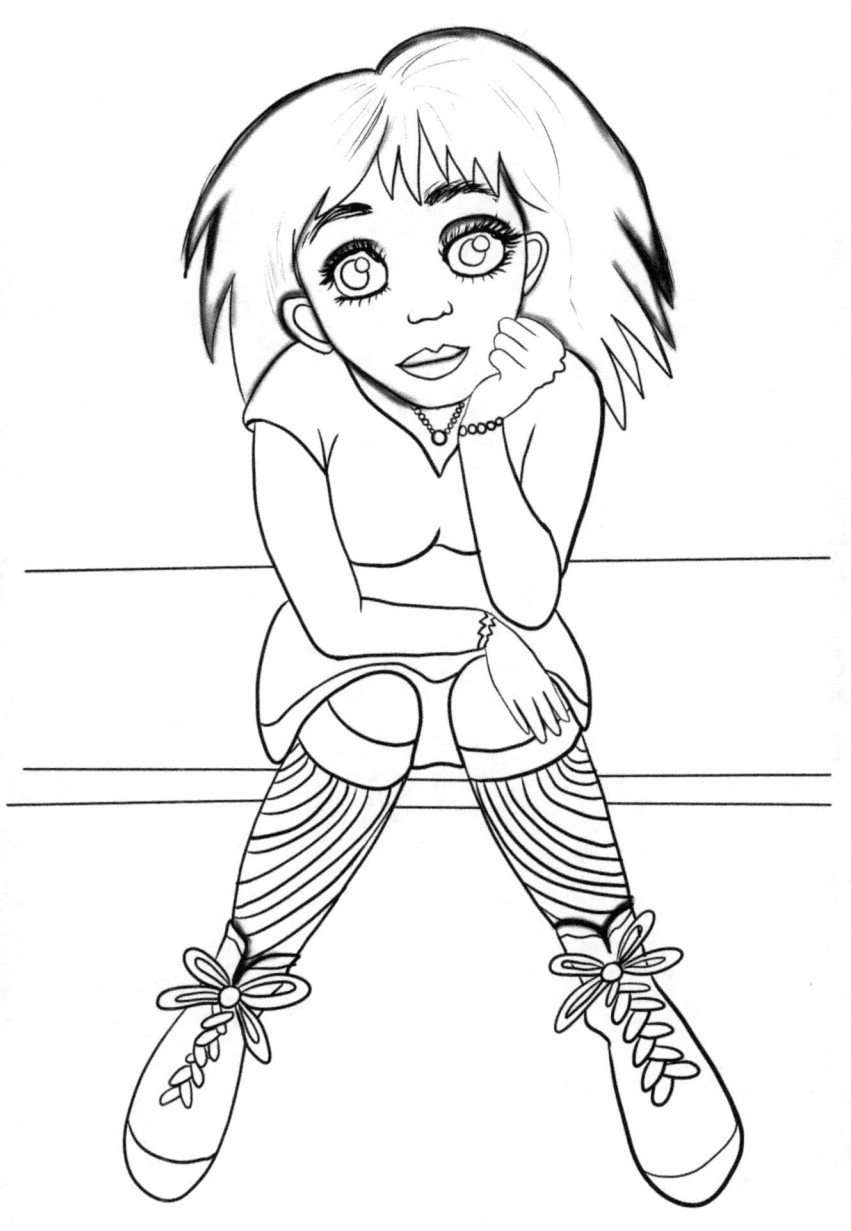

www.ingramcontent.com/pod-product-compliance
Lightning Source LLC
Chambersburg PA
CBHW061225180526
45170CB00003B/1165